T0316254

THEY HAVE OAK TREES
IN NORTH CAROLINA

Sarah Wooley

THEY HAVE OAK TREES IN NORTH CAROLINA

OBERON BOOKS
LONDON

First published in 2007 by Oberon Books Ltd
Electronic edition published in 2012

Oberon Books Ltd
521 Caledonian Road, London N7 9RH
Tel: +44 (0) 20 7607 3637 / Fax: +44 (0) 20 7607 3629
e-mail: info@oberonbooks.com
www.oberonbooks.com

They Have Oak Trees in North Carolina © copyright Sarah Wooley 2007

Sarah Wooley is hereby identified as author of this play in accordance with section 77 of the Copyright, Designs and Patents Act 1988. The author has asserted her moral rights.

All rights whatsoever in this play are strictly reserved and application for performance etc. should be made before commencement of rehearsal to United Agents, 12-26 Lexington Street, London, W1F 0LE (info@unitedagents.co.uk). No performance may be given unless a licence has been obtained, and no alterations may be made in the title or the text of the play without the author's prior written consent.

You may not copy, store, distribute, transmit, reproduce or otherwise make available this publication (or any part of it) in any form, or binding or by any means (print, electronic, digital, optical, mechanical, photocopying, recording or otherwise), without the prior written permission of the publisher. Any person who does any unauthorized act in relation to this publication may be liable to criminal prosecution and civil claims for damages.

A catalogue record for this book is available from the British Library.

PB ISBN: 978-1-84002-818-8
E ISBN: 978-1-84943-877-3

eBook conversion by Replika Press PVT Ltd, India.

Visit www.oberonbooks.com to read more about all our books and to buy them. You will also find features, author interviews and news of any author events, and you can sign up for e-newsletters so that you're always first to hear about our new releases.

Acknowledgements

I would gratefully like to acknowledge the following authors and their books: John Walsh, *Tears of Rage*; Paula S. Fass, *Kidnapped – Child Abduction in America*; and Mike Echols, *I know my first name is Steven*.

I would also like to thank the following for their help along the journey: Giles Smart, Paul Robinson, Will Smitheson, Joy Wilkinson, Lizzy Abusch, Jenny Worton, Dominic Cooke, Ruth Little, Paul Copley, Elliott Cowan, Linda Bassett, Graham Whybrow, Hanne Steen, Sarah Shavel, Janette Smith, The National Theatre Studio, The Lord Clyde Writers, Joyce Branagh, Alexis Peterman, Steph Farrell, Matthew Lloyd, Annelie Powell all at Theatre 503 and the Actors Centre and Raj and Blaise for all their love and support.

They Have Oak Trees in North Carolina was written in the Winter of 2005 and Spring of 2006, before the reappearance of Natascha Kampusch in Austria and Shawn Hornbeck in Missouri, USA and prior to the disappearance of Madeleine McCann in Portugal.

Characters

RAY
60s

EILEEN
Ray's wife, 60s

CLAY
an American, late 20s

A note on punctuation
The presence of a slash / indicates an interruption
by the next speaker, so that speech overlaps.

They Have Oak Trees in North Carolina was first performed at the Tristan Bates Theatre in a co-production with Theatre503 on 13 November 2007, by the following cast:

RAY Hilton McRae

EILEEN Janet Amsden

CLAY Simon Harrison

Director Paul Robinson

Designer Libby Watson

Lighting Designer Chris Davey

SCENE ONE

October. A room in a house. This is RAY *and* EILEEN'*s home.*
A large door on one side / back of the stage leading to outside.

RAY I

CLAY Yes?

RAY I
What I

CLAY Yes

RAY Want to know is…how?
How did you
It's been twenty-two years

CLAY I know

RAY Twenty-two years

CLAY Yes

RAY So how did you find us?

CLAY The newspaper

RAY They gave you our address?

CLAY No.
Yes.
They told me you hadn't moved

RAY So you you remembered?
Is that what you're saying?
You remembered where you used to live?

CLAY Yes.

Pause.

Sort of

RAY Sort of?

CLAY I couldn't remember the name of the village
They told me.
I came here.
I walked around a bit, followed my nose.

It hasn't changed

RAY You're American

CLAY Yes.

RAY I wasn't expecting an American

CLAY Weren't you?

RAY No

CLAY But

RAY Of course you should be I suppose if
Where do you live?

CLAY You mean now or

RAY In America?

CLAY Well I've lived all over
It's hard to say

RAY You can't pick one bit
One bit you'd call your own or?
Where did you live the longest?

CLAY Place called Burningtown

RAY Where's that?

CLAY North Carolina

 Pause.

RAY This is this is a shock a
People don't just
Do you understand it's

CLAY Yes

RAY And my wife
It's been *years*

CLAY I know, I know

RAY We haven't heard from anyone in a long time.
Of course we used to have a lot of people bothering
 us

 Psychics, letter writers

CLAY Letter writers?

RAY Yes

 People pretending they knew something

 My brother's uncle's been to Florida

 You know the thing

CLAY They were lying?

RAY Yes

 Maybe

 I don't know.

 One man came here, ten years ago

 Said he knew something

 Said he could help.

 My wife let him visit

 Only he didn't know anything

 Just wanted to listen to her talking, going over

 We found out later he used to go home and

 Well…

 You know

CLAY That's that's…sick

RAY Yes.

 I thought so

 We stopped seeing people after that.

 Pause.

 So you found this place by yourself?

CLAY Yes

RAY That's what you said

 You came alone?

CLAY Yes

 Although the reporter

RAY He wanted to come with you?

CLAY Yes

I told him not to
I wanted to speak to you first

RAY You want to sell your story
Is that it?

CLAY No

RAY Well there's no story to sell
Unless you are.

> *Beat.*

And you're not.

> *Beat.*

I'm certain you're not.

> *Pause.*

This…newspaper
Is it a tabloid?

CLAY A what?

RAY A tabloid
A red top?

CLAY ?

RAY Was there a scandal about some model or
An actor caught with his trousers down?
Was that the sort of newspaper you went to?

CLAY I don't know

RAY You don't know?

CLAY No.
But they were interested
Very interested
In me
In you

RAY Were they?

CLAY Yes
You've talked to them before that's what they said

RAY Years ago

CLAY When it happened?

RAY After we came home
We thought it might help
It didn't
Just encouraged the crack pots.

Short pause.

How old are you?

CLAY Twenty-seven

RAY You're the right age then
Problem is you look older

CLAY I do?

RAY Yes
I'd put you more…mid-thirties.
Have you been on the internet?

CLAY The internet?

RAY Websites?
Is that how you found about

CLAY No

RAY There must *be* stuff.
If you look
We had a photograph
They will have posted that somewhere on the world
wide web
I'm sure if you put the name into some chatroom or
search engine

CLAY Do you think your wife will recognise me?

RAY I didn't

CLAY Yes but women are more

RAY What?

Beat.

Gullible?

CLAY No, sensitive.
 Their memories are more

RAY Selective

CLAY Sensual.

RAY Sensual?

CLAY Yes

RAY What does that mean?

CLAY Well, perhaps there was something about me
 My smell

RAY Your what?

CLAY The tone of my voice
 The shape of my ear

RAY Your ear looks like any other ear

CLAY To you

RAY Yes

CLAY But not to her.
 She will have held me many times
 She knows every part of me

 Beat.

 Where is she?

RAY My wife?

CLAY Yes

RAY She's at the cottage
 We have another house we

CLAY Here?

RAY Yes.
 We rent it out
 We have guests coming this afternoon

CLAY That's nice

RAY It's not.
 It's a lot of work
 She has to clean
 Does it all herself
 We don't have a housekeeper
 And the people they

CLAY What?

RAY Well, depending on
 Sometimes they leave a mess they

CLAY Trash the joint?

RAY No
 Never that
 But if it's a group
 Women
 A hen party

CLAY So it's big?
 This house?

RAY No
 I wouldn't say big no

CLAY But you said parties
 Sounds like
 Sounds like this place is impressive

RAY Impressive?
 No
 I told you it's a cottage it's not big it's not

CLAY How many rooms?

RAY Not many

CLAY But you have groups stay

RAY Yes / but

CLAY So there must be plenty of bedrooms to
 accommodate

RAY No.

There are *three*
That's all and we have sofas sofas that pull out that

CLAY Become beds

RAY Yes
So it's not big
Not impressive not

CLAY When did you buy it?

RAY Years ago

CLAY You didn't own this cottage when I lived here did
 you?

RAY No
Because you never lived here.
I've never seen you before in my life!

 Pause.

CLAY You're certain of that?

RAY Yes
Things like this they don't just
Well, it's not very likely is it?
On a scale of one to ten the probability of it's low
 very low
There are very few examples of

CLAY You thought I was dead

RAY Yes
No
Our son not you

CLAY So you'd given up

RAY No no
Not given up no never

CLAY But the chances of this happening a reunion of this
 sort you think it's impossible

RAY No not impossible not
I never said impossible

CLAY I'm putting words in your mouth

RAY Yes.

CLAY And you don't like it

RAY No.

 Look, what do you want?

CLAY I want to meet my mother

RAY I think you should go.

CLAY But I want

 I want your wife to see me, she'll recognise she'll

RAY Please.

 I don't know who you are or what you want but I
 won't have my wife upset

 Do you understand?

 She was ill she

 took pills for years

 She used to cry every day

 I won't go through that again.

CLAY I'm not here to make trouble

 I honestly thought you'd be pleased to see me

 I just

RAY What?

 What do you want?

 Who *are* you?

CLAY I'm Patrick

 Your missing son

 I've come home.

 I knew you the moment I walked through the door

RAY But there is *nothing*

 Do you understand?

 Nothing that would make me think

 The way you look or

 Patrick would never have turned out like you

CLAY But for years I've tried to remember

to figure out to
I searched
and I found you.
I want a happy ending

RAY We don't have money
If that's what you want
Is that what you want?

CLAY No

RAY I earn nothing
I don't work
We never take holidays
My clothes are ten years old.

CLAY You don't work?

RAY No

CLAY But you used to

RAY Yes

CLAY You used to work in the town.

RAY Yes.
Everyone did
Everyone does
There are no jobs here unless you're a farmer or you
 work in the pub

CLAY Your wife.
She used to work in the pub
The one in the next door village

RAY She didn't

CLAY She did

RAY No

CLAY But I remember she went out she

RAY You remember?

CLAY Yes

In the evenings
She used to come home in the dark
She used to bring home chips

RAY Chips?

CLAY Potato chips

RAY You mean *crisps*

CLAY They must have sold them behind the bar.
The landlord
He'd let her take the chips
The crisps I mean
They were meant for me, she let me eat them in bed
I remember

RAY You don't.

CLAY I do

RAY You don't
She never did that

CLAY She did

RAY She didn't
If my wife had bought crisps I'd know about it

CLAY Would you?

RAY Yes

 Beat.

CLAY Well maybe she didn't tell you
Maybe, it was a secret

RAY My wife and I don't have *secrets.*
It's just been us all these years we
We are *good* people
We give to charity
We care about orphans and lost dogs and local
 schemes
We don't want trouble.

 Pause.

CLAY This room
It hasn't changed

RAY It has
We decorated last year

CLAY No
It's exactly as I remember it
This is where
On my birthday
we had a party.
Kids came and your friends

RAY No

CLAY You mean we never celebrated birthdays?

RAY No

CLAY But I remember
I had a cake
with blue icing.
I remember because I liked the colour
It was an odd colour not natural at all
It didn't make the cake look particularly appetising
 but I liked it because it was
Unusual
And as a kid I liked unusual things
Didn't I?

RAY I don't

CLAY Didn't I?

 Beat.

And where are the pictures?

RAY What pictures?

CLAY They're gone too
You used to have photographs
Over the fire
Me in a christening gown me at the birthday

The cake with the blue icing

RAY Why would I have pictures of a child I don't know?
I've never met you before
Until today
Until you rudely turned up in my garden / uninvited

CLAY Did you take them down?

RAY Have you been watching me?
Have you?
Have you been waiting?
Waiting to pounce while I cut the roses
Or put the bin out or stopped to post a letter or

 Beat.

Do you want to hurt me?

CLAY Where are your friends?

RAY Friends?
What friends?

CLAY You used to have photographs
Of friends
Right here.
They're gone too
Like the birthday snaps

RAY No

CLAY Yes
You were laughing
Drinking
On holiday
Somewhere in Europe?
Spain perhaps
You were happy
I remember those people very clearly
They were your guys
Mates from the old days
A man called Bill

I used to call him Uncle Bill
God I so remember / Bill

RAY Look
We don't see anyone, alright
Not anymore.
No one comes here

CLAY Why?

RAY What?

CLAY Why?
Do you not like company?

RAY No
Yes
But I've got my wife
The two of us we
manage very well
And this place
It's hard to find
It's a trek
Remote
At night it's dark
People don't like that
Driving home in the black it's not everyone's cup of
tea

CLAY But I found you.

RAY Yes
I don't know how
I shall be ringing the newspaper in the morning
I'll lodge a complaint

CLAY There are places
Up in the mountains up
Behind the cedar trees and the scrub oaks
No electricity
Just a lantern for light

The places I've lived
Used to terrify me when I was a kid

 Pause.

RAY I'm going to count to ten.
I'm going to count to ten then I want you to go

CLAY Remember the day?

RAY One

CLAY You were wearing khaki shorts

RAY Two

CLAY You had a red face from sitting in the sun too long

RAY Three

CLAY Mom had gone to the store

RAY Four

CLAY You stayed behind

RAY Five

CLAY She left me with you

RAY Six

CLAY You said you'd look after

RAY Seven

CLAY I went outside

RAY Eight

CLAY You *told* me to go outside

RAY Nine

CLAY You were at the window and

RAY Get out get out get out get out!

SCENE TWO

The same room. Later.

EILEEN Your hands

CLAY The same hands

EILEEN Yes
And your eyes they're

CLAY Green

EILEEN Like mine

CLAY Just like.

EILEEN Oh
Your hair too
You haven't changed

CLAY You have
You look like a different person

EILEEN I'm older

CLAY Yes

EILEEN A bit fatter

CLAY No

EILEEN And my hair
It's grey
It used to be black

CLAY That's right, I remember

EILEEN I've got a slight stoop
Look
The doctor says I've weak bones
My bones are crumbling like a cliff too close to the
 sea
I get pains in my fingers
See
My hands are like claws
Hope I haven't passed that on to you

CLAY I don't think so

EILEEN I'd have recognised you anywhere
After all these years
If I'd seen you in the street or
walked past you in a shop I'd have shouted
I'd have screamed
I'd have torn my throat out for screaming
I wouldn't have let you go.
Just look at you.
Come here
You're handsome
Good looking

CLAY Am I?

EILEEN Yes
And you're strong you're
Like a man

CLAY Well I am a man yes

EILEEN But no ordinary man.
Not any old member of the general public you look
 like
an actor

CLAY An actor?

EILEEN Yes
Not some guy in the background or some fool in a
 soap no
You look like
a superstar!

CLAY What?
No!

EILEEN You could be in films

CLAY Really?

EILEEN You could walk the red carpet

CLAY Come on

EILEEN Be in magazines
You'd sell thousands of copies

CLAY (*Laughs.*)

EILEEN Or
What about an athlete?

CLAY Athlete?

EILEEN Yes
Win a gold medal

CLAY At the Olympics?

EILEEN Yes
You could be a runner or a tennis player
If someone told me you were a famous tennis player
I'd believe them

CLAY Would you?

EILEEN Yes
Or you could jump hurdles or…swim
You could be a champion at swimming or
I know
a boxer.

CLAY Boxer?
You're kidding

EILEEN You'd glow in the ring

CLAY No way, I'd be scared
terrified
too frightened I'd get hurt.

EILEEN I feel proud

CLAY Do you?

EILEEN The way you've turned out
I'm impressed
It's not what I imagined.

 Beat.

CLAY What did you imagine?

EILEEN A child.

> *Beat.*

Never a man.

CLAY You thought I was dead?

EILEEN Sometimes
Sometimes that's what I wanted
It would have been easier
Until today the
not knowing
it was like living in mist.
I used to have dreams.
You were swimming in a river
Your face was green
You had seaweed in your fingers and
fish swimming in your hair
Or sometimes you'd be in the earth
All warm and brown
An animal would come along
A bear or a dog I don't know which and he'd snuffle
 the ground til he'd find you
Dig you up
Not dead
But not alive either.

CLAY That's awful

EILEEN It didn't feel awful
Waking up
Reminding myself
Remembering what had happened
That was horrible

CLAY I used to dream that I could walk through walls

EILEEN Did you?

CLAY I'd disappear into stone

I'd stay there til it was safe to come out
Sometimes the walls would eat me up
I had those dreams til I was fourteen
After that they stopped

Pause.

EILEEN We tried to look for you
You know that don't you?

CLAY Yes

EILEEN We had posters made
Went on TV
But things over there they were different.
The people
The money
The sound of them
It was so fast.
They talked fast, moved fast
Not like here.
Police said it happened all the time.
In the next state five little girls in two years
What was so special about us?
What was so special about you?
I said he's my son that makes him special
They said could you get a cuter photo.

CLAY I've seen that picture
Who took it?

EILEEN A friend of ours, Bill

CLAY It looks nothing like me

EILEEN I liked it
You look…thoughtful
Truth is it was the only one I had
It was the photo I used to keep in my purse

CLAY They didn't do a very good job

EILEEN The police?

CLAY Yes

EILEEN No
But then there were no systems, no special people to
 call
Not like now
Now they dredge the lake
Dust up fingerprints
Alert the helicopters
But they took statements
looked for witnesses
In the end only two people came forward
Do you know this?

CLAY No

EILEEN One was a teenager
Little girl really
One was eighty-three
Mentioned the same van
Blue
it was.
So they put out calls
Pulled people over
They were obsessed with that van, the police
They were on a mission:
Find the blue van with the number plate that no one
 could remember.
But a week later the teenager changed her mind
Well she was only young
Said the van might not have been blue
That on second thoughts, it might have been white or
 black
In fact
it might not have been a van at all

And in all that time I don't remember getting
dressed, waking up or going to sleep
I lost two stone
I got old

Pause.

Then the money ran out

CLAY How long?

EILEEN Did we stay?

CLAY Yes

EILEEN Three months
We had no choice
We had to go back
We knew no one.
You do understand?

CLAY nods.

Ray had to work
We had to
go on
And there was nothing you see
Not a hint or
We were only supposed to be there two weeks

CLAY A vacation

EILEEN That's right
Our first abroad
With you
We were having a lovely time
Do you remember?

CLAY Bits of it

EILEEN Two weeks in Disney World
It was my idea.
The flat rock camping ground.

CLAY Right in the middle of the woods

EILEEN Yes

CLAY I remember that
There were people next door but that was it
I remember there was a little lake and a shop

EILEEN That's right
Looked beautiful in the brochures
Wood cabins and

CLAY Pine trees

EILEEN Yes yes
Smelt like Christmas in June.

Pause.

I was gone ten minutes
Fifteen tops

CLAY I know

EILEEN That stupid shop
One shop for the whole campsite
for all those woods
I'd only gone for a few bits
nothing special it could have waited
Just food and a couple of toilet rolls
And it wasn't as though I'd left you alone
was it?

CLAY No

EILEEN It must have happened in a minute

CLAY Yes

EILEEN He closes his eyes or
turns the page in the newspaper
Thirty seconds of washing up
or a trip to the loo.
As soon as I realised
soon as we knew
I went crazy
running about

I didn't know where
No plan
Up into the woods
Down to the river bank
We ran into people's cabins
Barging into people's rooms
I was screaming your name
I was screaming Patrick! Patrick!
I remember standing in the middle of the woods with
 my arms in the air
screaming
Patrick! Patrick!

Pause.

Could you hear me?

CLAY No

Pause.

I was miles away.

Pause.

EILEEN The person who took you?
Did they
Did they treat you well?

CLAY They're dead

EILEEN But
Did they look after?
Treat you as their own?

CLAY Yes

Pause.

They treated me as their own.

EILEEN We always hoped
Was she
someone who didn't have children?
That's what the police

Someone who'd lost a child or
Is that why?

CLAY No

Pause.

No.

SCENE THREE

The same place, later.

RAY Look
Look!
Take a good look
See
See this picture this

EILEEN Put it away

RAY This boy
This boy is blond
See
See!
His hair
His hair is so white you can see his scalp
See the skin underneath the
Don't turn away
Look
Look!
He is dark
Dark hair
Dark skin
But this boy this one our one
He's fair
White
His skin's so white it's almost blue!

EILEEN Some babies are born fair
Their hair gets darker as they get older

RAY No
Not this one
No

EILEEN Yes

RAY No!

EILEEN My brother was born blond
When he was three his hair turned black
You look at old photographs you wouldn't think it was the same child

RAY But Patrick was *five*
Five when it happened
So any chance of going dark
That would have passed

EILEEN No

RAY Yes!

EILEEN No!

RAY Ok.
Ok ok
So now
Now
I want you to look at this
Look
Look!

> *RAY physically forces her to look. He has a copy of a missing poster. The child in the poster is the same blond child in the photograph but he's aged up. He looks about twelve.*

Had you forgotten?
You must have seen this a hundred times and yet

> *She snatches it from him.*

EILEEN Where did you get that?

RAY Where it's always been

See.
Nothing
Nothing like

EILEEN Put it away

He takes the poster back.

RAY Hair
Still blond
Skin
Still white

EILEEN So?

RAY *So?*

EILEEN That's an artist's impression
Someone's taken licence that doesn't mean

RAY But you always thought this was very good
this picture, this man's idea of
We were pleased with this because look
shape of the nose
Long
like mine
Lips
a bit thin
yours.
And look at this child
his build
Here he's supposed to be what?
Twelve? Thirteen?
But he's small for his age our son he's
puny
tiny
like my father
Would grow maybe what?
Five-four, five-five, six at a push?
The sort of boy who'd who'd

be a jockey or

EILEEN A jockey?

RAY Yes
Maybe or
I don't know
But he's a lightweight, featherweight
a wiry kind of guy a
Sammy Davies Junior

EILEEN Sammy Davies Junior was *black*
He had one glass eye!

RAY The American is six foot
He's got shoulders
Muscle
Arms like boulders
He's got concrete bricks growing up inside his skin
He's never Sammy Davies Junior.
He's…Brando in *The Wild One* or
Gregory Peck

EILEEN He's my son!

RAY So where has he been all these years Eileen?
Where did he live?
Who looked after him?

EILEEN He didn't say

RAY (*Mimicking her.*) Didn't say?

EILEEN No

RAY Did you ask him?

EILEEN I didn't want to upset him

RAY No no mustn't upset him.
A stranger comes here unannounced, to our home,
says he's our son and you don't ask where he's
been for twenty years!

EILEEN I couldn't

I told you he was upset

RAY *He's* upset?!

EILEEN I think

What happened that day that

I think we got it wrong

RAY Wrong?

EILEEN *Yes*

It wasn't

some girl who'd lost a baby

any of that

RAY Of course it was

EILEEN No.

I said to him, I said was it someone who didn't have children?

Some desperate woman or

he said no

RAY then what did he say?

EILEEN Nothing

He was upset

I told you

RAY But what about the witnesses?

EILEEN They must have been mistaken

RAY No!

They weren't mistaken

That's what they saw

EILEEN One of those witnesses was eighty-three years old

Ray

RAY So so?

She always seemed very sharp to me very

So, what is he suggesting this stranger this

EILEEN A man

I suppose

RAY A man?

EILEEN Yes some

Oh I don't want to think about it

RAY There was no *man*

EILEEN Says who?

RAY *Everyone*

No one has *ever* mentioned a man

EILEEN All these years we've created a picture of what
happened but it's not based on anything known

Just bits of scraps of things

Well what if none of it was true?

Maybe, what happened was much worse than we
wanted to imagine.

RAY But that girl she said she saw a woman

and the police said that was the most likely

always said that didn't they?

They did checks

EILEEN Of people who were known to them

That's all

I've heard about this happening, read about it

Poor mothers of missing daughters hoping their kid
will one day come through the door say, 'Hello
mum I'm fine,' when in reality they're lying in a
back garden somewhere waiting to be dug up.

RAY Jesus

EILEEN And when the police come and tell them the truth
the mothers they never say,

'Well that's no surprise. I'd been expecting that,'

cause you don't think the worst you hope for the best.

Otherwise it'd kill you.

Pause.

RAY He tried to tell me you worked in the pub

EILEEN What pub?

RAY In Nettlebury
The George
He tried to tell me that

EILEEN What did he say?

RAY That you used to go out in the dark
Come home late
Bring back crisps or something

EILEEN He said that?

RAY Yes
I told him no I said no she never did that never.

EILEEN Maybe I did

Beat.

RAY What?

EILEEN Maybe I did maybe
Maybe, I worked in the pub

RAY Don't be ridiculous

EILEEN Why is it ridiculous?

RAY You've never worked in a pub in your life

EILEEN I might have

RAY You haven't

EILEEN How do you know?

RAY I know

EILEEN Are you sure?

RAY *Yes.*
What's wrong with you?

Pause.

EILEEN Do you remember when I did that course?

RAY What course?

EILEEN At college
English literature

RAY That was years ago

EILEEN Well maybe I wasn't at the college
Maybe I made that up
Maybe, I was working

RAY In the George?

EILEEN Yes

RAY You bought textbooks for that course
You used to write essays

EILEEN How do you know?
You never read them
You never showed *any* interest

RAY But I'd smell it on you
Pubs, they stink
Fags and ale disgusting aroma

EILEEN You never went in the George
I could easily have been there
You wouldn't know

RAY Someone would have told me

EILEEN Who?
You never speak to people
You never bother with anyone.

RAY Yes I do
Then I did

EILEEN Like who?

RAY What?

EILEEN Like who?
All you wanted to do was stay in

RAY I was tired
Looking after a kid I was tired so were you

EILEEN Tuesdays and Fridays six til nine
That's when I worked

RAY Six til nine?
 What kind of shift is that?
 Six til nine

EILEEN Jack Carver was the landlord
 I pulled pints
 washed glasses
 served spirits

RAY You didn't

EILEEN I took orders
 used the till
 I knew everyone's drink and everyone's name and I
 brought home crisps

RAY For Patrick?

EILEEN For Patrick

RAY and I didn't know

EILEEN You didn't know.

 Pause.

RAY Why have you never mentioned this before?

EILEEN Never needed to

RAY And you do now?

EILEEN Yes

RAY So all these years you've lied to me?

EILEEN No, I just didn't tell you that's all

RAY and that's not lying?

EILEEN No

RAY not telling is lying

EILEEN It's not

RAY It is in my book

EILEEN Your book?

RAY My book yes.

Pause.

So, what was I doing while you were out working?

Pause.

Minding Patrick?

EILEEN Yes

RAY Sitting at home looking after him

EILEEN Yes

RAY Playing with him?
Talking to him?

EILEEN (*Not looking at him.*) That's right

RAY Playing nicely?
Making up games?
Reading a story?

EILEEN Yes
Yes!

RAY I think you've forgotten what Patrick was like

EILEEN What?

RAY Either that or you've decided that boy is the better
option

She hits him hard across the face.

Jesus!

EILEEN I wish we'd never gone on that holiday

RAY (*Still reacting to the strike.*) Jesus!!

EILEEN I wish I'd never left him with you

RAY You hit me

EILEEN If only we'd stayed at home!

RAY So it's my fault is it?
A great place to take a kid that's what you said
You never stopped going on about it
You saw the advert on television after that you were
seduced

EILEEN It was your idea to go abroad
Let's go on holiday lets get away
It'll be a new start a chance to

RAY We should have gone away *alone* just us two
Paris, Venice, Amsterdam
That's what *I* wanted

EILEEN (*Laughs.*) What *you* wanted?
You didn't have the right to get what *you* wanted Ray.

 Pause.

Make or break that holiday wasn't it?
Your last chance.
'Whatever you want', you said
'Whatever you want I'll do it'

RAY So you blame me blame me because

EILEEN Yes.
Yes I do blame you as it happens
if it wasn't for *all that*
We never would have gone

 Beat.

RAY (*Low.*) You overreacted

EILEEN No

RAY You jumped to conclusions

EILEEN No

RAY I never did anything!

 Pause.

EILEEN All these years
All these years without friends

RAY You don't need friends you've got me

EILEEN It should have been different.
What was the plan?
Summer fairs, cream teas, get involved in village life

RAY We do get involved

EILEEN What a trip to the post office on a Thursday?

An envelope with a donation for the new church hall?

A church hall you've never even seen!

RAY It was *you* that stopped the socialising

EILEEN Me?

RAY Yes, don't blame me

You stopped the visits, the drinks, the walks all that was you

EILEEN And why was that?

What choice did I have?

 Pause.

I've never felt so ashamed in all my life.

RAY No

EILEEN Her coming here and

RAY No

EILEEN turning up

warning me

shouting

RAY Shouting?

She'd never do that

EILEEN Oh but she did

I was standing over there

Patrick was crying

She was yelling at me

'Can't you tell your husband to stop obsessing to'

RAY You make it sound

EILEEN Like what?

RAY Like I *stalked* her!

EILEEN Well, didn't you?

RAY No!
 No you know I didn't
 She just
 We had

EILEEN What?
 What did you *have*?

 Beat.

 That's right
 Nothing
 But you kept on
 wouldn't leave her alone
 Pestering her and

RAY I didn't

EILEEN So following her home from work
 ringing her at four five in the morning that wasn't
 pestering her?

RAY I never did that

EILEEN They were our *friends* Ray
 for years
 Bill was your best man

RAY It wasn't my fault she

EILEEN What?
 Was nice to you?
 She listened when you complained about Patrick
 Smiled when she poured the coffee at the end of the
 meal?
 Laughed at your bad jokes?
 She was *being* a friend
 Our friend and you

RAY No
 Not just
 She encouraged me she

EILEEN Wanted you arrested!

RAY She didn't

EILEEN She was going to the police
That's what she said
And you stole from her

RAY No!
Who told you that?
Bill?

EILEEN Was it
Was it that time in the garden?
It was summer
We were looking at the plants
The lavender, the hollyhocks.
The weather was warm
She'd made dinner.
You disappeared
She noticed you were gone
She got up
Wondered if you were alright
Was that when?
Were you in her bedroom then?

RAY No

EILEEN Rifling in her cupboards her bedside table stealing
her things her

RAY No!

Beat.

EILEEN She sent me a letter
After Patrick went missing

RAY I didn't know that

EILEEN I didn't tell you.
She said she'd seen us on *That's Life* talking about
Florida
About Patrick about
what the police hadn't done, the campaign

She said if I ever needed anything not to hesitate
If we needed money or
just to talk she
and Bill
they'd be there.
She wanted to forget
She wanted to forgive
But I was too embarrassed too humiliated.
She was offering me comfort and I couldn't take it.
Because of what you did
How you made me look!

 Pause.

RAY It's him who's done this
Coming here
Causing trouble
Everything was fine
We were doing fine til he turned up

EILEEN No Ray.
We weren't doing *fine*.
We haven't been *fine* for years

 Pause.

RAY Why didn't you leave me?

EILEEN I wanted to
I was going to
That holiday was your last chance
But then Patrick went missing and

RAY What?

EILEEN I wanted to be here in case he came back

 Pause.

Anyway, you could have left me

RAY But I didn't

 Pause.

EILEEN No

> *Pause.*

RAY I'm sorry
I'm sorry I
But we never talked / and he

EILEEN He'll be back tomorrow
He's picking his things up from the hotel then he's
coming here.
You need to go over to the cottage there's something
wrong with the heating

RAY Eileen please love

EILEEN While you're out
I'll call the newspaper
Tell them they have got a story
'Missing boy returns after twenty-two years, mother
delighted.'

SCENE FOUR

> *The same place the next day. A table with buffet style food is
> being set by EILEEN and CLAY. They take food / plates etc. to
> the table during the following dialogue.*

EILEEN Like a key turning in a lock
That's what it felt like
deep down
Sort of…right at the bottom of my stomach
That was the first time

CLAY Must have been turning around, moving
Plates?

EILEEN Over there
You kicked a lot.
And you were very sensitive to noise.
I remember that
The sound of shouting or a car backfiring

you'd kick me so hard I'd be doubled up.

CLAY There are some mountain folk, who believe that
when a baby first kicks
It means that the spirit of the child has entered the
woman's body

EILEEN Isn't that fascinating

CLAY Where I come from, some folk, they'll believe
anything.
Where do you want these?

He lifts up some plastic cups.

EILEEN Over by the drinks.
They can help themselves.

They continue to set up.

I was only in labour for four hours

CLAY That was quick

EILEEN I nearly didn't make it to the hospital
I nearly gave birth in the car

CLAY Ray's car?

EILEEN Not the one he's got now
In those days he drove a Ford Cortina.

CLAY It was red, I remember
That was the car that was always breaking down?

EILEEN Yes

CLAY There was something wrong with the / radiator

EILEEN Radiator
How do you remember that?

CLAY Well it used to make him mad, the radiator

Pause.

So I wasn't born in the country?

EILEEN No no
You were born in the town

You have dirt in your lungs
The sound of traffic in your ears

CLAY Why did you move?

EILEEN Wanted to be somewhere safe, I suppose.
Somewhere quieter, better for a child
We had friends who lived in the next village
We used to visit
It seemed nice.

Beat.

I missed the town.
We had a flat next to the supermarket then
And when you were little, the woman from
 downstairs, she used to come up and
we'd sit on the fire escape, fussing you and drinking
 tea.
I'd sit and stare at you all day and you'd look right
 back
Always looked straight in my eyes.

Pause.

I didn't want to move.

Pause.

CLAY I have a son

EILEEN A son?

CLAY Yes

EILEEN Why didn't you tell me?

CLAY He doesn't live with me

EILEEN Oh

CLAY His mother she
It's complicated
I have to go to court
She won't allow access
She's…sort of a bitch

EILEEN She…doesn't let you see him?

CLAY No

It didn't work out her and me and
this is her way of punishing me

EILEEN That's awful

CLAY Just want to see my kid you know
I want to spend time with him, have fun
Kick a ball, toss a frisbee
I want him to have all the things I couldn't.
And he's growing up fast
I'm missing out

EILEEN How old is he?

CLAY Four
He's four

EILEEN My grandchild.

Beat.

CLAY Yes

Beat.

Of course yes

EILEEN You were very young, when you had him

CLAY May as well have kids when you're young
That way you've got the energy

EILEEN I was old
Thirty-five
That's not old now but back then
Everyone used to ask us, when are you going to get
on with it?
I wasn't that keen at first
I hope you don't mind me saying that

CLAY No

EILEEN Me and Ray we were happy you see just us

Us two.

But we thought we ought to think about it
And Ray said he might regret it if we didn't
and everyone else we knew was doing it so

Pause.

I don't know why I hesitated why I
Cause once you were born nothing else mattered.

Pause.

CLAY I've got to go back to the states for a hearing next
month

EILEEN Next month?

CLAY Yeah
She's got some hard-assed lawyer
Mine's a dope

EILEEN I hope I get to meet him one day?

CLAY Who the lawyer?

EILEEN No your son my

CLAY Yes, I know
I was kidding
I hope you get to meet him too.

Pause.

EILEEN Before you came here
Before you found us
You had another life
I keep forgetting that

Pause.

I know nothing about you

CLAY You know I'm your son

EILEEN Of course but... I don't know details
How you've lived your life, who your friends are or
You haven't talked about these things

CLAY I don't want to

EILEEN But I've got to have something, do you understand?

CLAY Why?

I'm here now, isn't that all that matters?

Pause.

EILEEN Every night, before I'd fall asleep, I'd go through a different scenario.

Today Patrick lives in a beach house in Florida

Tomorrow an apartment in New York

A boat on the Mississippi

A loft in Seattle

I'd picture you in every city I'd seen on television.

I'd watch the news

The bigger the event the better

If there was a flood, an earthquake, the *Oscars*

Anything with a crowd I'd be there

eyes right up

searching the background

looking for you.

Beat.

Remember the millennium celebrations?

CLAY nods.

Well I stayed up til five in the morning waiting for Washington

Who's that guy in the red jacket?

Or that boy there with the party hat and the happy face?

When those reports came in on September the eleventh I stayed up for three days.

I taped it on video

Every member of the crowd paused and pawed over

Every fireman checked out and ticked off

I peered over the shoulder of a woman crying for her
 dead husband because
that might be you in the blue jumper covered in dust,
 surviving
But now you're here
All flesh and blood and I don't need to imagine
 anymore
You can tell me what's real and what's not.
You can tell me what happened

> *Silence,* CLAY *looks straight out front or puts his head
> in his hands.*

You'll have to tell *them*
They'll want to know everything
What school you went to what job you had
Did you even go to school?
You see I don't know
But they'll want to know it all, in detail, it's expected
and they won't be afraid to ask.

CLAY I wasn't very good at school

EILEEN So, he
 *did...*put you through school then he

CLAY Yes.

But I preferred the holidays
I'd hang out
Climb trees
Smoke
Skinny-dip in the lake

> *Beat.*

You know one summer, me and a friend, this girl, we
 went fishin' practically every day

EILEEN You weren't bored?

CLAY Bored?
What?

Fishin'?
Shit no I loved it

EILEEN Ray tried to take you fishing once

CLAY He did?

EILEEN Yes
But you were too young too
You didn't have the patience.

CLAY I really
I don't remember

EILEEN No, of course you don't
It was just once, just one time.
Sorry, you were saying, you and your friend

CLAY Me and this girl, well we had a canoe

EILEEN (*Laughs.*) A canoe?

CLAY We used to row out into the middle of the lake and
attach these little red pellets onto a hook and line
We didn't catch much, just guppies
And the lake had leeches

EILEEN Ugh!

CLAY Yeah
Slimey little bastards
Freaked her out
and mosquitoes too
Man they'd eat you alive
You'd be all bitten up by noon.
But I loved it
I felt…free
Stopped me thinkin' too much

EILEEN Wish I could have seen you
Playing out in the open, you and your friend
It sounds like
You did have…moments

When you were happy?

You were able, sometimes, to enjoy yourself?

CLAY I guess

Pause.

EILEEN Did you never try to to

leave him to

run away?

CLAY Once.

I was ten

I made it down to the highway but ended up getting
lost

The trees cast long shadows in the dark

It was cold the snow had only just thawed

I was scared.

He found me…

I never tried again.

Silence. CLAY *moves away from* EILEEN, *his eyes fall
on the buffet for the press.*

I didn't expect all this

I didn't think

All this fuss and

I didn't think they'd send a TV crew.

EILEEN It's a big story

CLAY Yes but

one newspaper I thought that's all just one

EILEEN But this is wonderful news Patrick

The world is waiting.

If you'd followed our story after all these years
wouldn't you want to know how it ended?

And they've been very good

They don't usually do it like this

Usually, you have to go to them but this is special
that's what they said

They want pictures of you back at home, safe with us,
where you belong

Beat.

We should go through what we plan to say, get our
story straight.

CLAY You make it sound like we're lying.

Beat.

EILEEN It might be an idea to write things down
Get things clear, that's all.

Pause.

When it happened when he
You did tell him about *us*?
The man I mean the
You must have known we were looking for you

CLAY He said you didn't want me
He said your parents don't love you no more
I'm your father now
This is your new name
I was five
I believed him

EILEEN But people at the school they must
You would have had an accent
You would have stood out

CLAY I was no different from the other kids

EILEEN No but you were you

CLAY You say that
but people they don't look
They've got their own lives their own kids to raise
their own worries.
What does it matter to them what goes on behind the
trailer door
People believe what they're told

Pause.

EILEEN You said he gave you a new name
 What did he call you?

CLAY Clay.
 Short for Clayton
 I'm used to it now
 At first I wasn't so keen.

 Beat.

 Donna, she wants to change my son's name
 He's got a new father too
 She wants to call him after this guy's fucking dad or
 something

EILEEN Can she do that?

CLAY Can do what she likes
 Unless I get custody.

 Pause.

 I think when you change someone's name their old
 self disappears
 You're reinvented, repackaged
 Your past belongs to someone else

EILEEN When I got married and changed my name
 I didn't feel like me anymore.

 Pause.

CLAY What's Ray gonna say when he gets back?
 Finds half the world's press in his front room while
 he's been waiting for the fuel guy to come?

EILEEN We'll talk to him

CLAY The last time I talked to him he threw me out
 If the reporters think he doesn't believe then

EILEEN Don't worry
 I'll talk to him.

Pause.

Clay.
Short for Clayton.

SCENE FIVE

Same place an hour later.

RAY Like one of those people those
grubby people
Trisha people
Whores
Criminals
Obese men with fifteen tattoos and fifteen kids
That's what we'll be

EILEEN Shush!
He's only upstairs he'll hear

RAY Someone to point at
to whisper
Is that what he wants?

EILEEN Shush!
I asked them here not him
It was my idea

RAY I won't be able to go out!

EILEEN You don't *go* out

RAY Walk down the street
Go to the post office buy cigarettes

EILEEN You don't smoke

RAY I won't be able to post a letter
Potter in the garden
Open the front door for a parcel

EILEEN What parcel?

RAY The whole world will think we're idiots
Sad old people who'll believe anything

They'll think I've got early Alzheimer's
They'll look at us and sigh
I'll have to suffer strangers' pity

EILEEN We'll work out what we're going to say
Work it out
It'll be fine

RAY Once they've got you on tape that's it you know
It's not like the old days where they'd use it again
Go over with something more important
Every blink
every nod
every silence not filled they'll grab it.
cut and edit
replay *forever.*

EILEEN He's got a son.

RAY Who has?

EILEEN Patrick

RAY He's not
don't keep calling him that!

EILEEN He's my grandson Ray
I won't let you stop me from seeing him

RAY Seeing who?
Who?
He's not
If he's got some kid it's nothing to do with us

EILEEN I want him here
I want him to go to school in the village
He's only four / but he can start next term in the
juniors

RAY What?!
This child?
Is it here?

EILEEN No and his *name* is Bailey

Isn't that a nice?
He's in America now with his mother
But we'll go to court / get him back

RAY For Christ's sake *court*?!
What are you talking about?

EILEEN Keep your voice down he'll hear!

RAY I don't care!
I go out for half an hour
half an hour to check on the on the

 Beat.

Why didn't we have another one, eh?
It wasn't too late was it?
A girl maybe
A little girl who was into dolls and dressing up
I could have taken her to playgroup and when she
 got home we could have baked cakes
And as she got older she'd have known how far to go
 with me
how far to push
cause me and her we would have understood each
 other
fathers' daughters that's what they do

 Pause.

Why did you turn away from me Eileen?

EILEEN You know why

RAY No, no it wasn't that.
You say that put the blame the
but that came later
You'd hung me out
let me dry up
years before that.

 Beat.

I was a catch me, once

EILEEN (*Scoffs.*)

RAY No no hang on *you* said that.

Used those very words yourself I remember

EILEEN No

RAY Yes.

You said it to that friend of yours in the office what
was her name?

Dark rimmed glasses and flicked up hair

Pause.

EILEEN Violet

RAY Yes, Violet.

'I've got a good one me' – that's what you said

'He's lovely looking, good at his work and he
wants…*me*'

EILEEN I was a kid

RAY You were twenty-nine.

You said, 'I'm lucky,' that's what you told her.

Pause.

You loved him more than me.

EILEEN No I didn't

RAY After he was born I became invisible

What did I do Eileen?

Why did I disgust you?

Pause.

EILEEN Remember

It was Patrick's birthday

I bought a cake

A cake with yellow icing

We had friends round.

Maureen and Alasdair Clarke, Bill and

Of course this was all before…before all that

Patrick was waiting for me to take a photograph

When all of a sudden, he put both his hands in the air
 and brought his fists down

hard, on top of the surface of the cake.

Of course the cake exploded there was sponge
 everywhere.

He smeared some over his face

Some went in his hair

It was even in his eyes, clinging to his lashes.

We hadn't had a chance to cut it

Let alone light the candles

It was ruined.

And he turned to me, Patrick and

giggled

waiting for me to laugh back I suppose, maybe take a
 photograph, record the

moment.

Him, with his cakey cream hands.

But then you shouted.

Broke in with your big man's gruff

and you grabbed him by his little wrists and dragged
 him to the sink

You forced his hand under the cold tap, he was
 crying big sobs as he was straining to reach the
 water

and you kept jerking his hand upwards til he was
 stretched out

like a monkey hanging off a tree.

 Pause.

You didn't deserve another child

And you still disgust me

 Silence.

RAY He said he remembered that birthday, the American
 But the icing on the cake was blue not yellow

EILEEN Maybe it was blue

Maybe I got that wrong

RAY No
It was definitely yellow.

CLAY enters.

CLAY I've been making notes
Like you told me
I've written quite a lot

EILEEN Can I read it?
Or if you want to…

CLAY Out loud?

EILEEN Yes why not
Out loud is good

RAY moves to go.

You need to listen to this

RAY It'll only be bunch of lies, a work of fiction

CLAY Is this how he's going to be when they get here?

EILEEN It's important we go over this Ray

RAY I'm going

CLAY But if he's
Mom you said

RAY What did you call her?

CLAY Mom I called her Mom

RAY Is this a *joke*?

EILEEN If you go Ray
You go for good.

RAY considers this, realises she is serious and reluctantly sits.

(*To* CLAY.) Ok
Go on please
We're ready

CLAY reads the following. He reads in a rather stilted self-conscious way, like a child.

CLAY I believe that I am Patrick Moreton

I believe that I was born on December the Eighth, 1979

I was born in England and although I lived in the city at first I was raised in the country.

I am my parents' only child.

In June of 1985 I went on vacation to Disney World, Orlando

It was a dream vacation for me as I was looking forward to meeting Mickey Mouse and all his / friends

RAY Mickey Mouse?

EILEEN (*Warningly.*) Ray

Pause.

CLAY It was my first vacation abroad.

There may have been other vacations in England but I don't remember

Is that...?

EILEEN Keep going

CLAY On the morning of June the Seventh, my mother, Eileen Moreton, went to the store

I wanted to go with her but she wouldn't let me

RAY You going to let him say that?

EILEEN Yes

RAY Makes you look bad

EILEEN No it doesn't

RAY Yes it does

Makes it look like you abandoned him

EILEEN I didn't abandon him

RAY But that's what it looks like

EILEEN (*To CLAY.*) Did it feel like I abandoned you?

CLAY Don't think so

RAY Well that's what it sounded like

EILEEN Plenty of mothers leave their kids behind when they
go out
Especially if they're behaving badly
I didn't want a scene
and I didn't leave him on his own
I left him with you remember

RAY So we can agree that he was behaving badly

EILEEN What?

RAY Patrick, he was behaving badly?

EILEEN Reasonably badly, on that particular day yes

RAY Reasonably badly?

EILEEN As badly as kids do when

RAY What?

EILEEN When they're tired or

RAY Tired?
At eleven o'clock in the morning?

EILEEN Yes.

CLAY Shall I [continue]

EILEEN Yes

RAY Hang on
Suppose, you'd taken him with you
what would have happened?

EILEEN Happened?

RAY Yes
If Patrick had gone with you, to the shop, what would
have happened?

EILEEN I don't know
I didn't take him did I

RAY But what would he have done if you had taken him?

EILEEN Done?

RAY Yes done
What would he have done?

EILEEN I don't know what he would have *done*

RAY I think you do
I think you have an idea

EILEEN No
Look, I didn't take him so I can't imagine what it
 would have been like if I had taken him
It's all…hypothetical.

RAY What was he like when you usually took him out?

EILEEN Fine he was fine
I didn't tend to take him shopping you know that

RAY And why was that?

EILEEN Patrick didn't like shopping
(*To* CLAY.) Did you
Who does?
You don't.
I don't.
(*To* CLAY.) Go on please

CLAY After my mother left
I stayed with my father, Ray Moreton
He was washing up at the sink
I went to play outside

RAY Where did you get that from?

CLAY Pardon?

RAY This detail this
I was washing up
Who told you that?
Did you get it from the newspaper?

CLAY No

EILEEN Ray stop it.

RAY Because it was in the paper
That bit about me washing up
I remember
I've still got the clipping

EILEEN Ignore him

RAY I'm just saying
none of this so far is very original is it?
It's all known it's all

EILEEN (*Talking over RAY to CLAY.*) Thank you

Pause.

CLAY I went outside
My father could see me from where he was standing
at the sink
I was playing a game
I was enjoying playing the game

RAY What was the game?

CLAY What?

EILEEN He won't remember that

RAY He ought to
What was the game?

CLAY I can't remember

RAY Thought not

EILEEN Ray!

CLAY But I'm sure if

EILEEN You don't have to remember everything
Don't feel you have to

RAY I think he has to

EILEEN Why?
It's a game!
A game he played when he was five

 How is that important?

 What's important is

RAY I think it *is* important

 I think we should be interested in the details

EILEEN Minor details

RAY Yes ok minor details but it all counts

 All adds up to

CLAY Tag

 I played tag

RAY Tag what's tag what's

CLAY You know, where you chase someone and then tap
 them on the shoulder and

EILEEN You mean catch?

CLAY Catch no

 Catch has a ball this is

 you run and whoever gets back to base first – kind of
 like hide and seek

EILEEN You mean tick.

 I think you mean tick

CLAY Someone stands at a base like a base could be a / tree

EILEEN I think that's tick

 You played tick

 See you remembered.

 He did remember the game

RAY That's not a game for one

EILEEN What?

RAY That game, whatever its name, it requires two or
 more to play it

EILEEN Oh

 (*To CLAY.*) sorry, maybe I confused you

CLAY No

 I'm not confused

We're talking about the same game
Tag or tick whatever
that was the game I played

RAY But it can't have been you idiot

EILEEN Don't call him an idiot!

RAY But you can't play that game on your own that's

CLAY I wasn't on my own

> *Beat.*

EILEEN You weren't alone?

CLAY No.

> *Beat.*

> *He* was with me

> *Beat.*

> Mydel

RAY Mydel?

CLAY Robert Mydel
My new father the
Of course I didn't know that at the time
If I'd have known that / I never would have

EILEEN Robert Mydel that was his name?

RAY For God's sake!

EILEEN Shut up Ray!

CLAY Yes

EILEEN And
What?
He was outside was he when you were playing?
When you went out he was

CLAY There
Yes
He was standing there right there when I came out of
the cabin

RAY No!

There was no one outside

I should know I was at the window

CLAY You didn't see him

He called me over said, 'Come over here bubba I'll play with you'

I must have been crying, mumbling under my breath cause Dad

I mean Ray he wouldn't play with me he didn't want me inside

He sent me outside to play on my own

EILEEN He sent you outside?

Is that what you did?

You *sent* him out outside

RAY No.

Look he was crying I tried to calm him down but

He went out on his own

I didn't know he was gone until

You know that

the police know that I've always

EILEEN (*To CLAY.*) What happened next?

CLAY He got me playing a couple of rounds of tag

RAY You would have been shouting

CLAY Shouting?

RAY Yes

Patrick could never play a game without shouting

Shouting and screaming

He'd get over-excited

CLAY Well maybe I was shouting a little maybe

RAY I would have heard you

EILEEN From inside the cabin?

RAY Yes

The window was open and anyway the walls were
 thin
Don't you remember?
We could hear the people next door

EILEEN Were there people next door?

RAY Yes
That woman with the red hair
We used to see her going out in the morning
We gave her a nickname
What was it?

EILEEN Oh never mind that now
(*To CLAY.*) So, you were playing and

CLAY Yes it was my turn to count his turn to hide.
He asked me to cover my eyes
He said cover your eyes and count to ten then come
 look for me
But I never got to ten

EILEEN Why?

CLAY He grabbed me
from behind
Put one hand round my waist and the other over my
 mouth
Next thing I was pushed into the passenger side of his
 van or car
I don't know which.
Next morning I saw it was a blue pick-up

EILEEN So there was a blue van

RAY This is ridiculous

EILEEN Shut up!

CLAY He swapped it next day for a saloon.
Did some deal with some Mexican in Georgia
We drove for hours

Drove through the mountains through thick forest on
 both sides

I don't remember him stopping

I guess he must have but I don't remember

RAY And you didn't scream or shout or

CLAY No, maybe a little at first but
 I don't know

Apart from him grabbing me he was kind of ok after
 that.

To me it was just some sort of game, an adventure

RAY So you sat impassively in the passenger side of this
 van, pick-up, car whatever

While this man this

tag-playing kidnapper

he crossed the state line did he?

CLAY Yes

Yes that's right.

RAY That would have taken hours

Patrick would never have sat quietly not even for five
 minutes

CLAY But I was scared I

RAY Scared?

I thought you said you thought it was all a game an
 adventure

EILEEN Shush!

Go on please

CLAY The next morning, I don't know what time it was but
 we stopped for breakfast

We drove a few more hours and checked into a motel

He left me alone in the room while he went and got
 food, exchanged the car

EILEEN He left you alone?

CLAY Yes

RAY And you didn't try to escape or

CLAY No
By this stage I thought
I thought this was all kind of cool kind of
no big deal you know.
I thought he'd take me back eventually
I thought I'd see you again

RAY You thought he'd bring you back?

CLAY Yes

RAY That's a rather a complex thing to have worked out

CLAY Complex?

RAY Yes
What you're saying is that you rationalised
You weighed things up

CLAY Yes I guess I did yes

RAY But our son he wouldn't have been able to do that
He wouldn't have rationalised
He wasn't capable of that

CLAY But from the stuff Mydel told me

EILEEN What did he tell you?

CLAY That
Well, at first he said it was a secret adventure and
 when I asked him if I was
going home he said
'Yes' but then I kept asking, 'when'
I was pestering him for information and
That's when he said he'd need to talk to you.
So he used the phone in the motel and he called
 someone.
He had a real conversation
I saw him use the phone

EILEEN But no one called here

We were on holiday there wasn't a phone in the
 cabin

CLAY I know that now.

But he was

He was pretending

He was pretty convincing too

nodding and waiting while the other person on the
 line spoke.

He was like, 'Uh huh' and, 'That's right ok'

It wasn't til later in the evening

when he sat me on his knee, then he told me that I'd
 never see you again.

He said you didn't love me no more

I said, 'No they do love me they'

But he said, 'No, you've been a bad son Patrick.

You've upset your Mommy and Daddy and now you
 have to live with me.'

I cried when he said that.

Then he took me to the sink and cut my hair and
 then he dyed it.

He must have known that the cops would release a
 picture

I remember looking in the mirror and I didn't
 recognise myself.

I knew then that my life had changed forever

But worse was still to come.

EILEEN Why, what happened?

CLAY Well…that night

Pause.

that night he he….undressed me and

EILEEN Oh God

CLAY He asked me to sleep in his bed and

RAY No I'm sorry but just spare us! /

EILEEN Ray!

RAY No no sorry but he abused you did he?
That's what you're going to say isn't it?

CLAY I think the word abuse is a very general term

RAY Really

CLAY Yes it doesn't *begin* to / describe

RAY Christ!
You really have thought about this haven't you?

EILEEN For God's sake!

RAY This is for the newspapers is it?
You think this is what they want?
If there's…what?
you get more column space is that it?
They'll pay more I suppose

EILEEN Ray!

RAY It's all lies Eileen!

CLAY (*To EILEEN.*) I'm not lying I promise

RAY You know, I remember reading an article once
'bout some murderer some guy who'd killed
I don't know how many hundreds of old ladies.
But the thing was he hadn't abused them.
Not raped them
Not had sex with them after they were dead nothing
like that

EILEEN Ray for

RAY No listen.
But he'd killed a lot of people, this man
In fact he was quite prolific.
And this journalist she said her fellow reporters they
weren't that interested in this
particular case because the story didn't have any *sex*
in it.

But 'Boy gets kidnapped and abused comes back to
 tell his sensational tale' that's
got it all hasn't it?
And he knows that
that man that *whoever* you are.
He knows that's what they really want
And you know what?
It fascinates you too Eileen
Cause they've got you all programmed
all set up
You don't want the truth, the real story no
You want the souped up movie version lie!

CLAY It's not a lie why would I lie about

RAY (*To CLAY.*) What is it you actually want?
It must be the money
It could *only* be the money or is this just something
 you do?
It's your thing is it?
You arrive at people's houses make up stories ruin
 people's lives
Well you won't ruin mine.

 Beat.

Patrick was taken by a woman
A woman who wanted a child was desperate for a
 child or or
could offer our son more attention more love more

CLAY You fucking asshole!

RAY What did you call me?

CLAY I called you a fucking asshole
Are you that heartless that

RAY Heartless?
You're *heartless* coming here and spinning your
This happened to us

77

This is our *life*!

CLAY I'll prove it
I'll get a test
A DNA test

RAY You can't lie on a *test*
Do you actually think a test would come up positive?

EILEEN What do you mean 'more love'?

Beat.

RAY What?

EILEEN you said someone who could offer Patrick 'more love'

RAY (*To CLAY.*) I want you out of my house
You're crazy
Go on get out
Get out!

EILEEN You think someone else could have been a better
mother to Patrick?

RAY No no not a better mother no

EILEEN Then what?

RAY Look I don't know I don't

EILEEN You think that what happened was for the *best*?
Is that what you think?

RAY No no but

CLAY You don't know how I've lived

EILEEN Ray?

CLAY No one to mind that I don't have shoes to walk in

RAY I don't care

EILEEN Ray?

CLAY A trailer
cooking fat all over the the door the ceiling dog hairs
clinging to

RAY Shut up!

CLAY Every night, I was sodomised

RAY (*Laughing.*) Jesus! Sodomised?
(*To EILEEN.*) He says this with a straight face!

CLAY He forced me to suck his cock

RAY NO!

CLAY And he did the same to other kids
He used me as the bait
I was his live in sexual partner / from the age of five!

RAY You *weren't*!

CLAY But these things happened to me!

RAY Ok well maybe they did happen to *you* maybe
But they didn't happen to our son!

EILEEN How do *you* know?

RAY Because that's not Patrick Eileen
You *know* it's not
Whatever you might want to believe whatever
it's not *him*!

EILEEN What makes you so sure?

 Beat.

What makes you so sure Ray?
What do you know?
What do you know that I don't?

 Beat.

What happened between you and Patrick after I left
for that shop?

RAY NOTHING!

EILEEN Ray?

 Beat.

Oh God
Did you hurt him?

 Beat.

Did you
Did you kill him?

RAY *Kill* him?
Patrick?
No *Christ* how can you
I gave our son a *chance* that's what!
I gave *us* a chance

> CLAY *suddenly violently grabs* RAY. *He pushes him up against the table with the food on it.* EILEEN *screams.*

CLAY You fuckin' bastard

RAY Get off me get

EILEEN Clay!

CLAY You think I'm going to listen to this
Listen to this crap from a shitty little man like you

EILEEN Clay!

CLAY I've come all this way and all you can do is mock me?!

RAY Let go you're hurting / me

CLAY Hurting?
You don't know what hurt is you fucking
I'm big now
I'm a man
I can do whatever I want!

EILEEN Stop!

RAY Let me go!

CLAY Look at these arms
Can you feel me?
Feel?

> *He tightens his grip again.* RAY *calls out. So does* EILEEN.

RAY Ahhh!

CLAY I could be a boxer
 See
 She said that

EILEEN Stop!

CLAY I'm gonna to get what I want here do you hear?
 Do you hear me?

RAY Help me! Help!

EILEEN Please

CLAY Now you are gonna sit with me and her you're gonna
 tell these TV people you tell them I'm your
 missing son!

RAY (*Struggling.*) No no

 CLAY shakes RAY.

CLAY Say: 'You Are My SON'

RAY (*Choking.*) No

CLAY Say it say it!

RAY No!

 RAY manages to break free. He cries out and pushes
 CLAY with real force.

EILEEN Patrick!

 CLAY falls against the table, he lands hard. Cuts his
 head. After a moment he puts his hand to feel his
 forehead.

CLAY Oh…

 With all his strength and rage RAY now makes to
 attack CLAY.

RAY You fucking

 CLAY is in a corner and puts his hands up. He
 immediately looks defenceless.

CLAY No! No! No! NO!

EILEEN drags RAY off CLAY.

EILEEN Leave him leave him / you'll hurt him you'll

RAY It was him

You saw

He tried to kill me!

> *As she pulls RAY off they both notice the blood which is now coming from CLAY's head. The next section of dialogue should run fast and can at times overlap.*

EILEEN Look what you've done

RAY That's it blame me blame me

Take his side

Do what you always do

> *CLAY looks at the blood on his hands. He reacts to it like a child.*

CLAY Blood

EILEEN (*She goes to CLAY.*) Oh God

RAY Don't help him

EILEEN Leave us!

CLAY I wanted

I *need* this

I need

Fuck fuck!

EILEEN Let me see

> *CLAY touches his head again.*

CLAY Blood

EILEEN (*She takes his hand.*) It's okay, you'll be alright

CLAY FUCK!

EILEEN You're ok

CLAY (*To EILEEN.*) But what about my son what about

EILEEN I *know*

It's ok
I know

CLAY (*Holds out his hand to her.*) Blood

EILEEN You'll be ok

She takes his hand.

CLAY Hurts…

CLAY starts to cry.

EILEEN (*To RAY.*) What have you done?
What have you done to *me*
What did you do to *my* Patrick?

RAY Oh yes that's right
Your Patrick your son *your* boy never mine

EILEEN You didn't *want* him

RAY I didn't get a *chance* to want him

EILEEN You were pathetic
You never knew what to do

RAY You never let me near him
In the beginning I tried to help but you wouldn't let
me

EILEEN What did you do with him Ray?
What happened after I left for that shop?

Beat.

RAY I want you to know that what I did I
I didn't plan it or

EILEEN Ray

RAY It was to save to

EILEEN Tell me

RAY go back

EILEEN Tell me.

Silence.

RAY Remember what he was like just before you left?

 Beat.

 Well do you?

EILEEN Yes.

RAY Well he got worse
 Much worse
 This was a whole new level of kicking, screaming
 I tried to calm him down but he bit me
 There was blood
 I got cross I told him, 'Go outside'

EILEEN So you did tell him to go outside?

RAY Yes, but I was watching at the sink I promise he

 Pause.

 He was out there no more than ten minutes

 Pause.

 I don't know where she came from
 One minute he was alone and the next
 It was like a magic trick.
 She just appeared
 Popped up
 Like she'd arrived through a trap door in the earth
 She had dark hair, was about our age maybe older
 When I thought about it later I realised I'd seen her
 before.
 She'd talk to Patrick, hang around smile and
 Well, she had a way about her
 I could tell
 she was *good* with him.
 Not like me not like
 She was wearing a blue dress
 White shoes
 She was bent down talking to Patrick right at his level
 She was whispering in his ear

I think…he was holding her hand

Now he'd never do that with us, would he?

Do you remember?

He'd always shrug us off or pull away.

And as I watched them I saw that she was starting to move

Just a little, slowly

Looked like nothing

Looked like she was his mother and this was her son and they were just innocently moving on, going home or

But they were getting further and further away

Slipping off the surface of

When I realised what was happening

When I saw what she was doing I went out there, rushed out

I was about to say –

'Hey, what are you

what where are you going with?'

but then she turned

and Patrick turned

and for a minute…it was just me.

Big green space

Smell of pine

I felt…light

I stayed like that for, I don't know, ten minutes maybe twenty

I couldn't move

> *Pause.*

I wanted to stay light

EILEEN Oh Ray, he was our boy

RAY I didn't like him Leeny

And we were stuck with him

EILEEN Was I such a bad mother?

RAY No no
But you never talked you
I know you found it hard
Because he was no better for you than he was for me
But you never admitted never said
And every time you bit your lip, held your tongue
Something was growing inside me
Dirty little grey spores

 Pause.

Maybe, maybe if you'd been there
If it had been you

EILEEN No Ray, I wouldn't

 Doorbell rings.

 Silence.

 Doorbell rings again.

CLAY Who's that?

 Pause; they all listen.

EILEEN The TV people

 Pause.

 Doorbell rings again.

 And again / maybe someone thumps on the door.

CLAY What you gonna do?

 Pause.

 Doorbell again or knocking.

 Doorbell rings without stopping.

SCENE SIX

A week later. Same place.

EILEEN She was a widow
 The woman who lived in this house before us
 She was eighty-six
 She was doing fine on her own
 She was happy
 But her daughter she wanted her to move
 Go with her, live with her
 Thought she'd get into grief I suppose have a fall
 She wasn't too enthusiastic about going
 In fact, after I'd met her I said
 I said she'll be dead within a year that woman
 She doesn't want to leave this house.
 Six months later the man from next door got a call
 from the daughter
 She passed away two weeks after leaving

CLAY That's sad

EILEEN This had been her home for sixty years
 It was too late for her to go changing.

 Pause.

CLAY Are you nervous?

EILEEN No

 Pause.

 Are you?

CLAY Yes

EILEEN You shouldn't be

 Long pause.

CLAY You know
 I am
 I am

> sorry

EILEEN Don't keep saying that

CLAY I know but
> I keep thinking
> If I upset you with my my story my

EILEEN lies

CLAY Yes
> Lies
> I am / sorry

EILEEN You were very convincing
> You were good on the detail

CLAY Detail?

EILEEN Yes
> The bit about
> cutting your hair and
> what he…Robert Mydel
> All that, it felt very real very

CLAY Yes, sorry.

> *Pause.*

EILEEN Where did you get it from?

CLAY What, the bit about the man and

EILEEN Yes

CLAY From the TV…mostly
> There was a two part true to life movie about this kid
> who got kidnapped…
> got most of it from that

EILEEN I see.

> *Pause.*

CLAY You know, none of that happened to Patrick, you
> know that

EILEEN Yes, you said.

 Pause.

CLAY I wish
If I'd gotten his number or
But I had no idea where I was going and

EILEEN How long had he been there?
Can you remember?

CLAY About three months I think

EILEEN and he wasn't with you for long?
That's what you said

CLAY No
They moved him to another block
But we talked a lot.
I really liked him
We were…similar

 Pause.

EILEEN Tell me, again
Please
What he said about us?

CLAY Which bit?

EILEEN The bit about, knowing

CLAY Just that bit?

EILEEN Yes

CLAY Are you sure?

EILEEN Yes

CLAY You won't find it too painful or

EILEEN No
Please

CLAY Ok, well…he said that erm that he felt

EILEEN Yes?

CLAY Well, he remembered that things were difficult between you and Ray. And that…even though he was very young he felt that he was somehow the *cause*, of that difficulty. And when…when he went to live with…with her, the… other, he was…happier, sorry but he thought that you were all…probably…happier. Better off.

EILEEN But he sometimes thought about us, as he was growing up
remembered us, from time to time?
That's what he meant surely

CLAY Yes

EILEEN Because he remembered what this house looked like
He remembered our friends
The car Ray used to drive
He remembered that I used to work in the pub didn't he?
And he remembered the birthday cake with the yellow icing

CLAY I thought it was blue

EILEEN No, it was yellow

CLAY Oh, so he got that wrong

EILEEN No you did?

CLAY Sorry?

EILEEN You got it wrong

CLAY Oh
Yeah
I see what you mean yeah.
Pause.

EILEEN Do you think he was 'better off'?

CLAY I don't know
I mean
I only knew him for a short time so

But from what he said his…she…
She was kind to him, if that's

> *Beat.*

That doesn't mean that you weren't
That you
I mean I think

EILEEN That I was a good mother?

CLAY Yes
Yes
You lived in this nice house, you provided for him
 you didn't neglect or hurt him it was Ray who

EILEEN Yes but *together* we…

> *Pause.*

I wonder…what Patrick might have done with his life
Where might he go, after?
To live, I mean

CLAY I don't know
I really don't know

> *Pause.*

He loved the city
I remember that
I'm a country boy could never live in the city but he
 loved it
Never stopped talking about the lights, the noise, the
 people

EILEEN Did he?

CLAY Yeah
So perhaps he went there

EILEEN Which one?

CLAY What?

EILEEN Which city?

CLAY Oh.

Well I don't…he didn't say

Pause.

How long have we got?

EILEEN Not long
I told them to get here for nine

CLAY They're late

EILEEN We still have plenty of time
You need to learn to be patient

Pause.

CLAY You sure you've got everything

EILEEN Yes
Just have to get a present
A toy for Bailey
What do you think he'd like?

CLAY Bailey?

EILEEN Yes, I want to make a good impression.

CLAY Then, I guess…something big
Maybe a teddy bear

EILEEN A big teddy bear?

CLAY Yes
Don't think he has a teddy bear

EILEEN He must have
All children have teddy bears

CLAY I didn't

EILEEN Didn't you?

CLAY No.

Beat.

Never

Pause.

EILEEN Maybe I'll get something at the airport

I'm sure they'll have something

CLAY And you get the tax off

EILEEN Yes.

I hadn't thought of that

Beat.

I can't wait to meet him.

Pause.

CLAY You know, no one ever looked out for me

My whole life til I went to jail was a different town, another trailer park

Even when I was real small I was playing chicken on the rail tracks in the fog

Hanging outside bars waiting for…

I don't want that for my son

The thought of him callin' some other guy Dad it's

Not being with Bailey

It kills me.

EILEEN That's how it ought to be

Pause.

CLAY Shall I call the lawyer?

Get him to meet us after we get to the hotel?

EILEEN No, I want to get a new one

Someone better

CLAY Ok

EILEEN Someone tough

Pause.

CLAY I never

When I came here

I didn't expect, I mean…us

you

I didn't expect that

EILEEN I think
I'd like Bailey to call me Nanny
If that's alright with you?
Granny sounds old and Nan…well it's a bit common
But Nanny, I can just imagine him saying that
Can't you?

Pause.

CLAY It's nice here
This village this house
Sure you won't miss it?

EILEEN No

Pause.

Well…I'll miss the garden and the fields at the back

CLAY It's a cool garden

EILEEN Maybe not the garden just that big oak tree

CLAY They have oak trees in North Carolina

EILEEN I love the oak tree
That one is two hundred years old
Ray used to like the roses but I always preferred the oak tree
Not in summer it's too imposing then too leafy too bold
I prefer it in winter when it's bare, just a skeleton
It's at its best in November.

End.

www.ingramcontent.com/pod-product-compliance
Ingram Content Group UK Ltd.
Pitfield, Milton Keynes, MK11 3LW, UK
UKHW031252020325
455690UK00007B/83